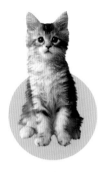

Cats Do The Cutest Things

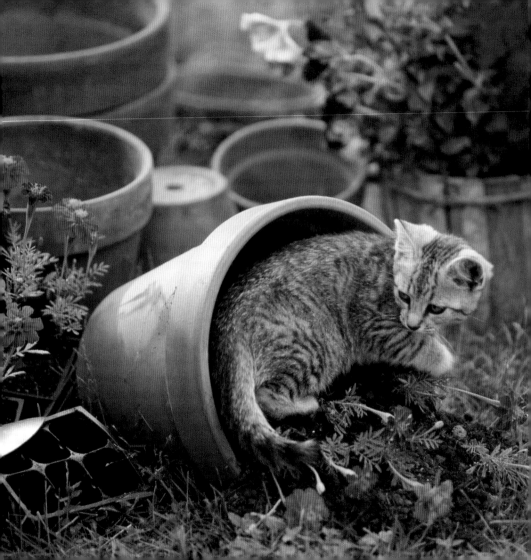

Cats Do The Cutest Things

Alexandra Ortolja-Baird

MQP

THIS BOOK IS DEDICATED TO AMELIA-JANE

PUBLISHED BY MQ PUBLICATIONS LIMITED
12 THE IVORIES, 6–8 NORTHAMPTON STREET
LONDON N1 2HY
TEL: +44 (0) 20 7359 2244
FAX: +44 (0) 20 7359 1616

EMAIL: MAIL@MQPUBLICATIONS.COM
WEBSITE: WWW.MQPUBLICATIONS.COM

ISBN: 1-84072-610-5

10 9 8 7 6 5 4 3 2

PRINTED AND BOUND IN CHINA

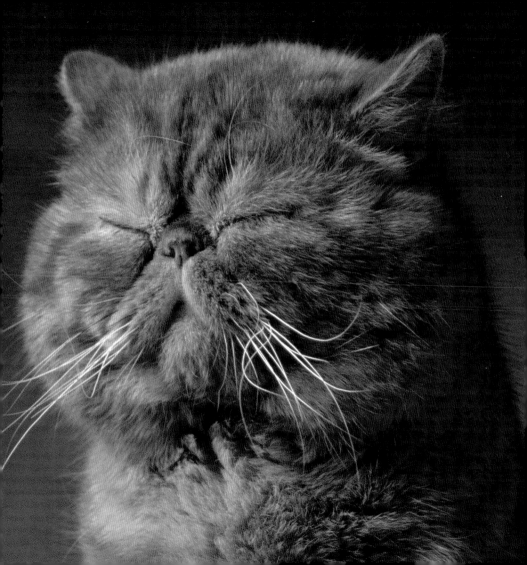

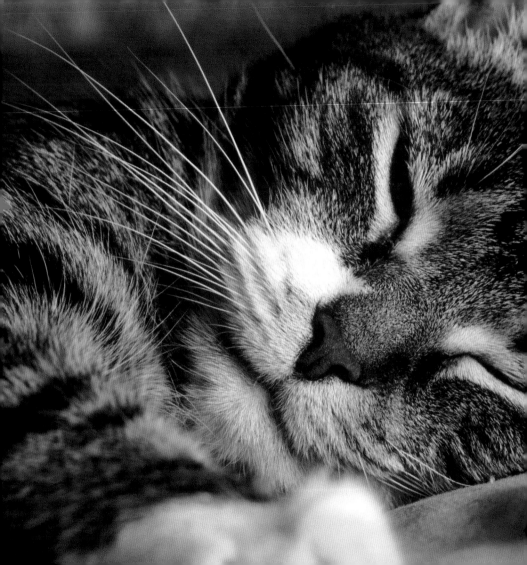

Cats are rather
delicate creatures
and they are
subject to a great
many ailments, but
I never heard of
one who suffered
from insomnia.

JOSEPH WOOD KRUTCH

7

After enlightenment, the laundry.

ZEN PROVERB

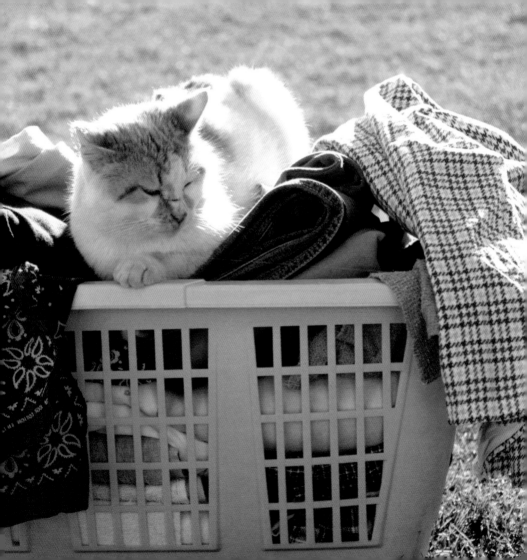

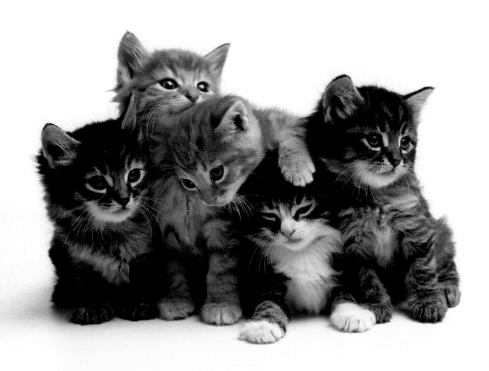

Up the airy mountain,
Down the rushy glen,
We daren't go a-hunting
For fear of little men.

WILLIAM ALLINGHAM

What is this life if, full of care,
We have no time to stand and stare.
No time to stand beneath the boughs
And stare as long as sheep or cows.

William Henry Davies

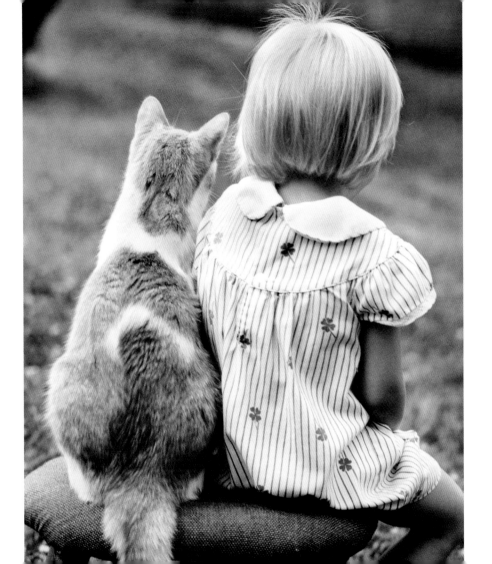

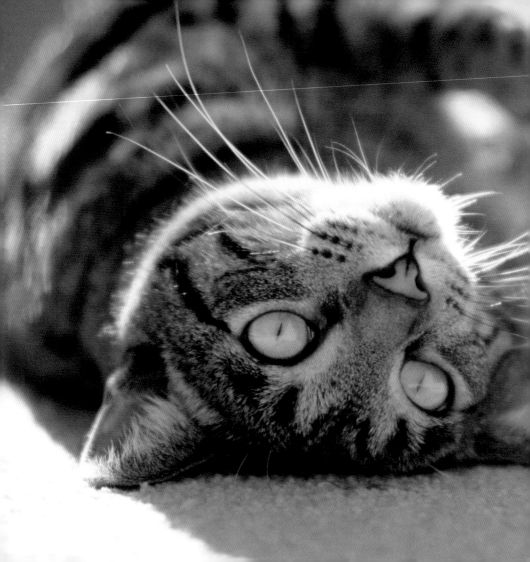

Tell me I'm clever,
Tell me I'm kind,
Tell me I'm talented,
Tell me I'm cute,
Tell me I'm sensitive,
Graceful and wise,
Tell me I'm perfect—
But tell me the truth.

SHEL SILVERSTEIN

Curiosity is the very basis of education and if you tell me that curiosity killed the cat, I say only the cat died nobly.

ARNOLD EDINBOROUGH

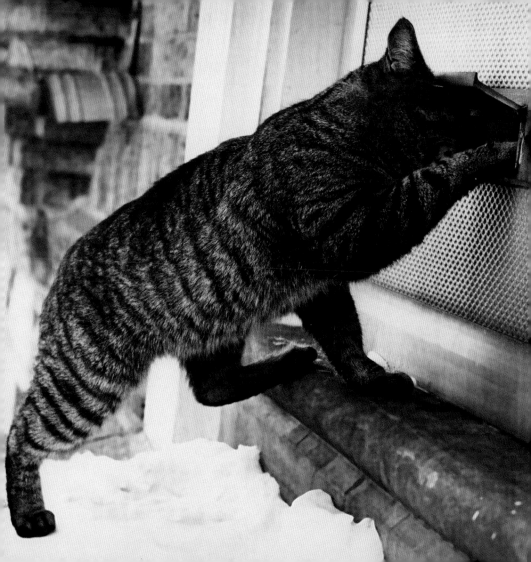

No amount of time can erase the memory of a good cat, and no amount of masking tape can ever totally remove his fur from your couch.

LEO DWORKEN

Look twice before you leap.

CHARLOTTE BRONTË

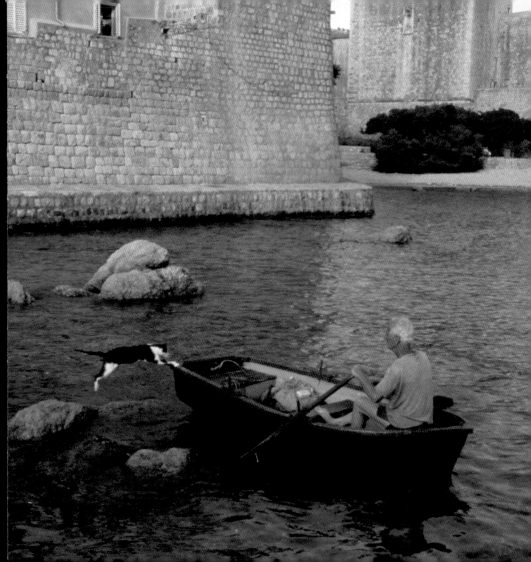

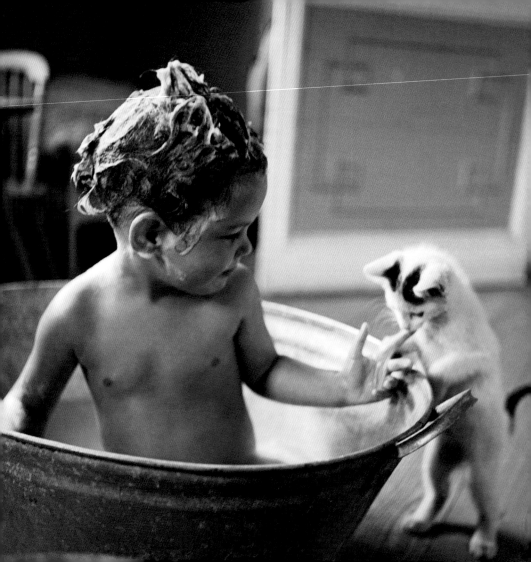

The cat Bastet sat perched on the rim of the tub, watching me through slitted golden eyes. She was fascinated by baths. I suppose the total immersion in water must have seemed to her a peculiar method of cleansing oneself.

ELIZABETH PETERS

In my experience, cats and beds seem to be a natural combination.

Louis J. Camuti

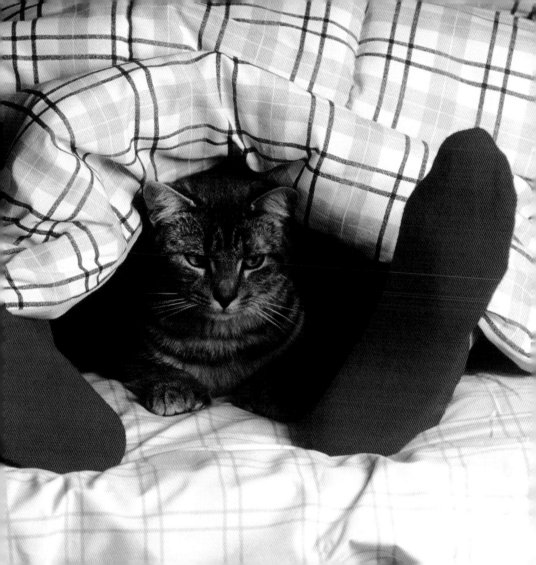

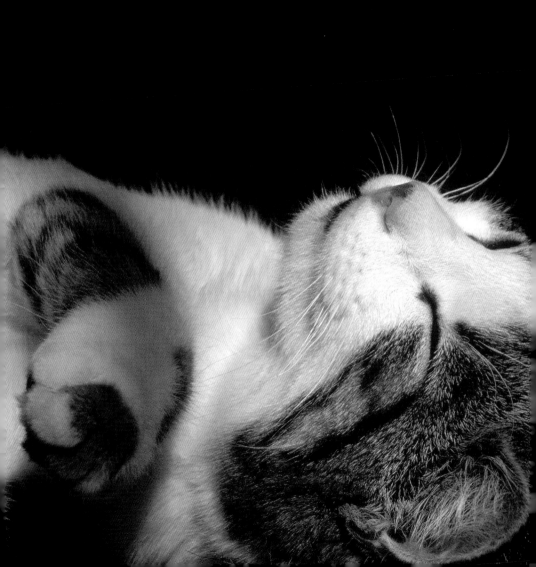

Sleep is the best meditation.

DALAI LAMA

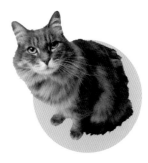

27

When you are out on a limb, the whole world is at your feet.

ANONYMOUS

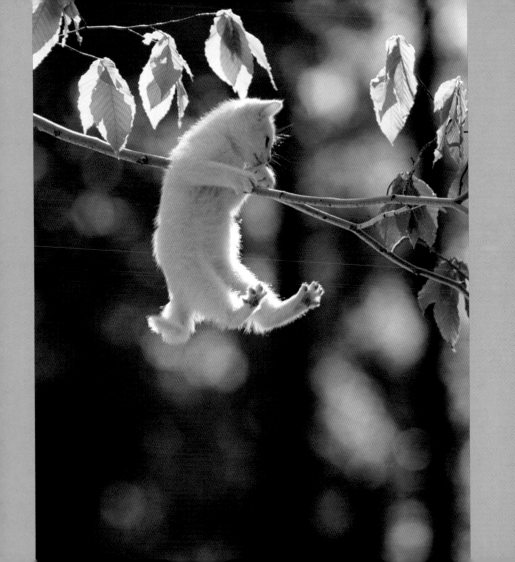

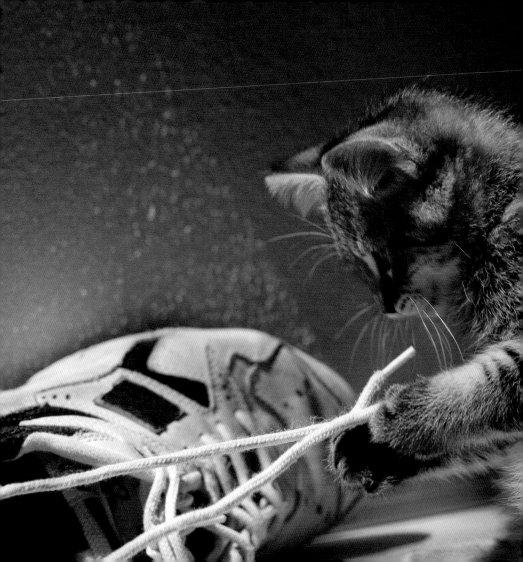

We learn the rope of life by untying its knots.

JEAN TOOMER

In a cat's eye, all things belong to cats.

ENGLISH PROVERB

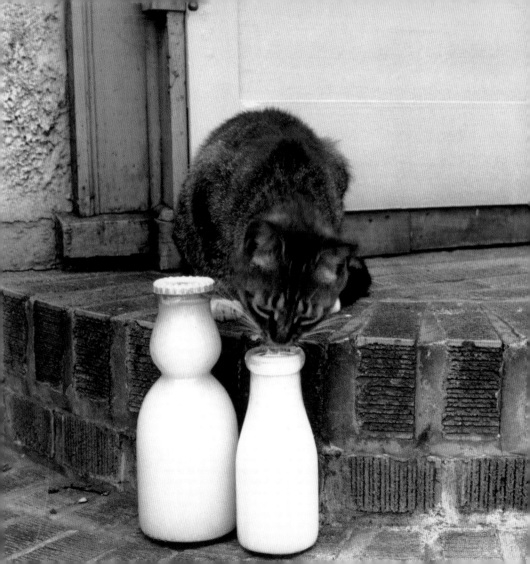

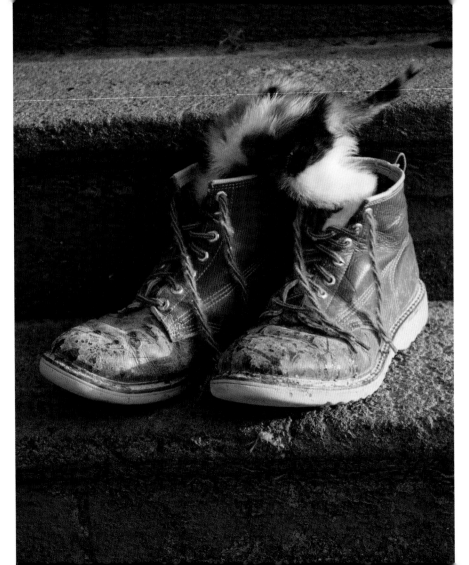

These clothes are good enough to drink in, and so be these boots too.

WILLIAM SHAKESPEARE

Cats are connoisseurs of comfort.

JAMES HERRIOT

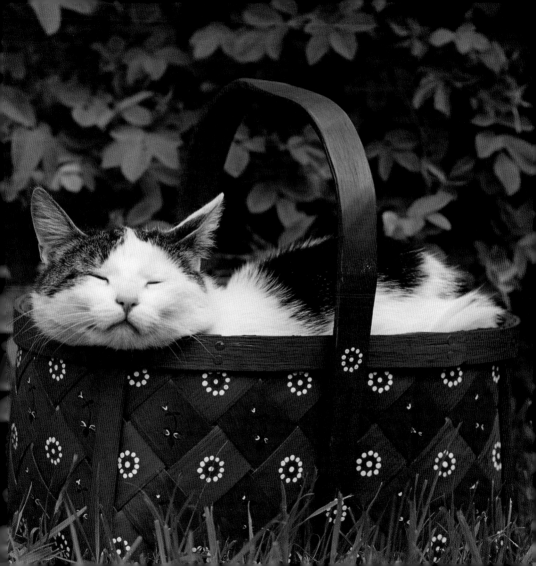

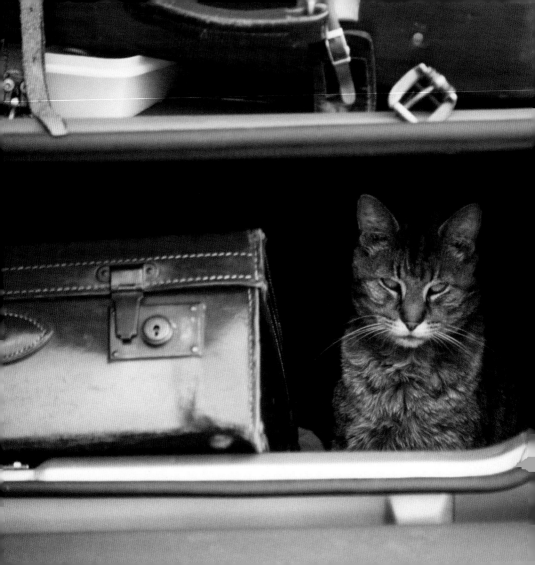

I may not have gone, where I intended to go, but I think I have ended up, where I intended to be.

Douglas Adams

O, what may man within him hide,
Though angel on the outward side!

WILLIAM SHAKESPEARE

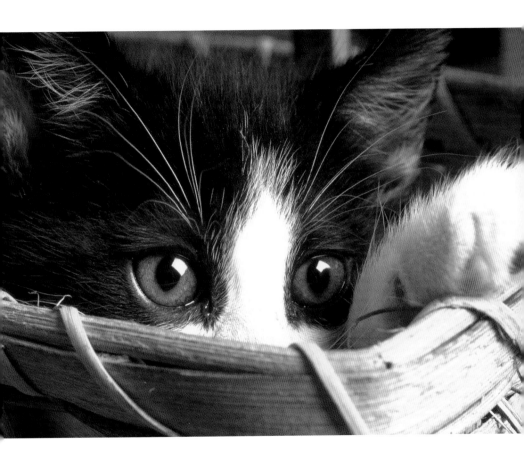

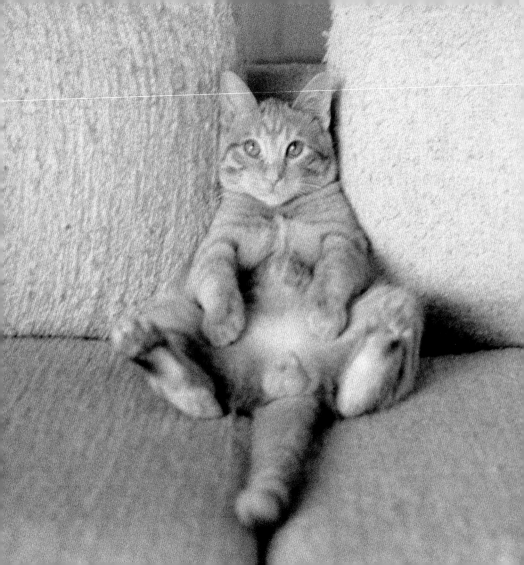

The ideal of calm exists in a sitting cat.

JULES REYNARD

I have never taken any exercise except sleeping and resting.

MARK TWAIN

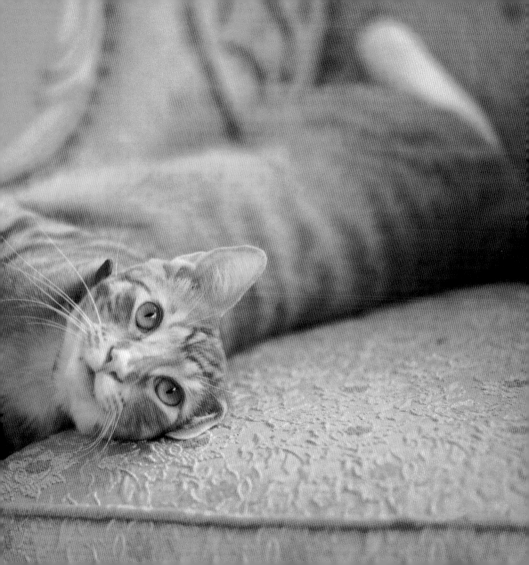

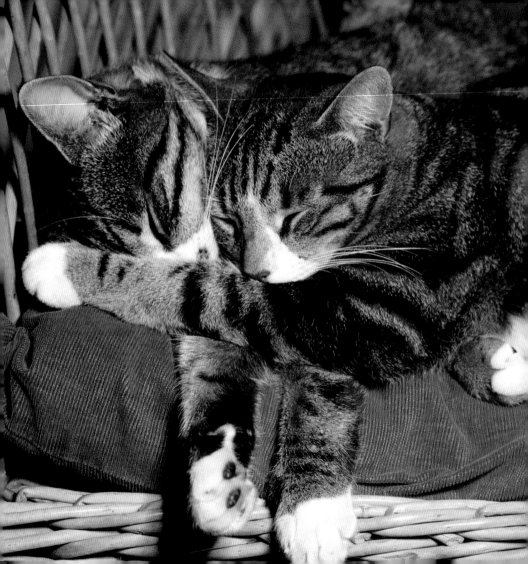

Cats sleep fat and walk thin.

ROSALIE MOORE

Dogs come when they're called; cats take a message and get back to you later.

MARY BLY

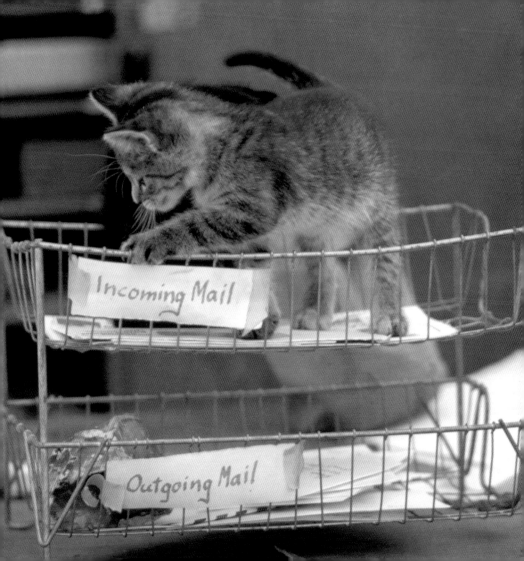

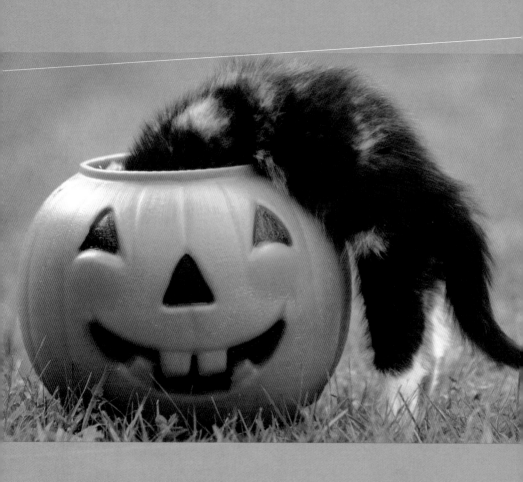

Research is formalized curiosity. It is poking and prying with a purpose.

ZORA NEALE HURSTON

I am impelled, not to squeak like a grateful and apologetic mouse, but to roar like a lion out of pride in my profession.

JOHN STEINBECK

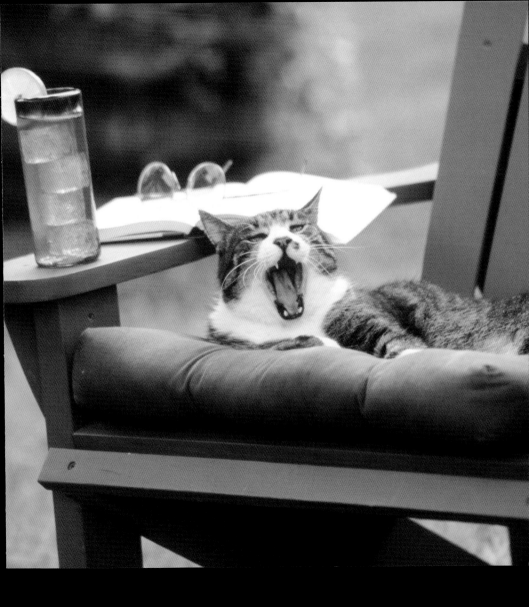

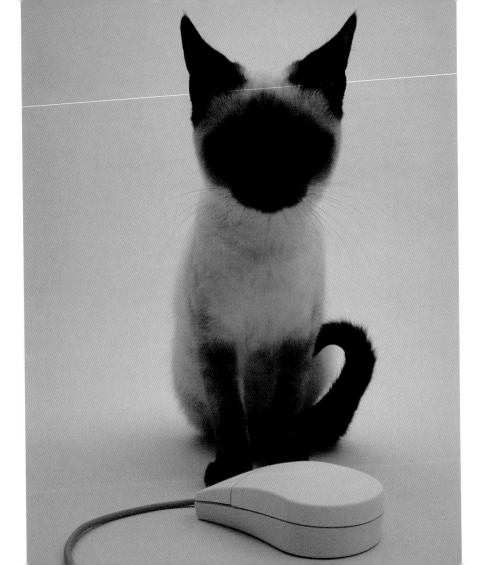

Do not meddle in the affairs of cats, for they are subtle and will pee on your computer.

BRUCE GRAHAM

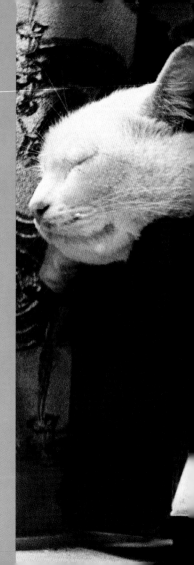

Life seems to go on without effort, when I am filled with music.

GEORGE ELIOT

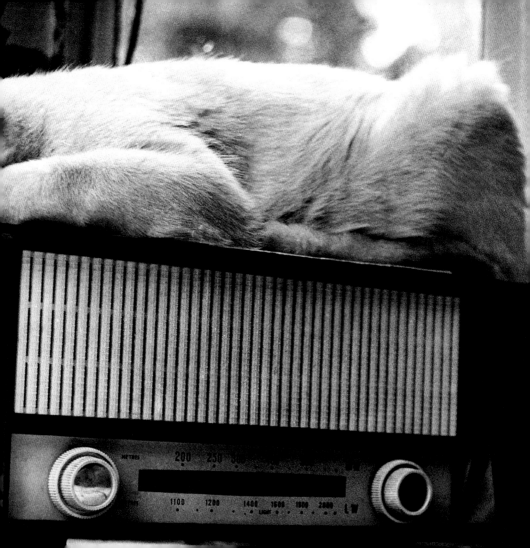

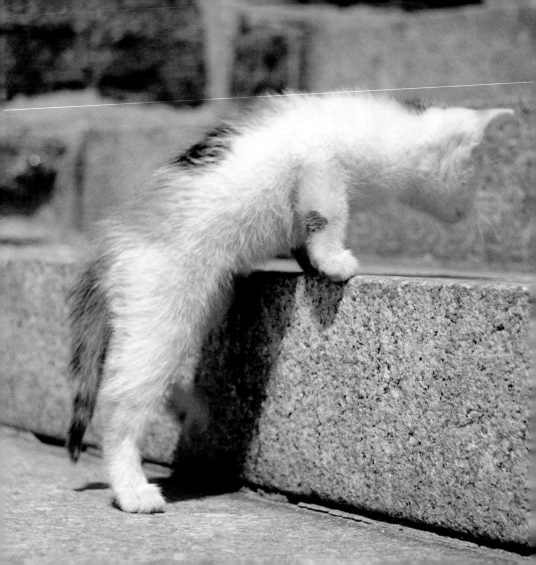

Climbing would be a great, truly wonderful thing if it weren't for all that damn climbing.

JOHN OHRENSCHALL

59

Before I compose a piece, I walk around several times, accompanied by myself.

ERIK SATIE

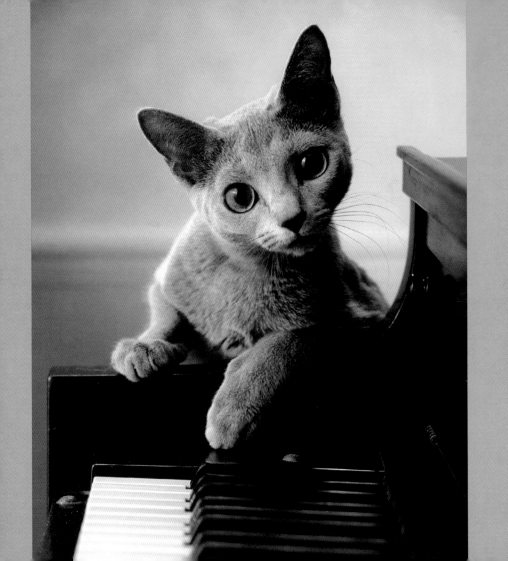

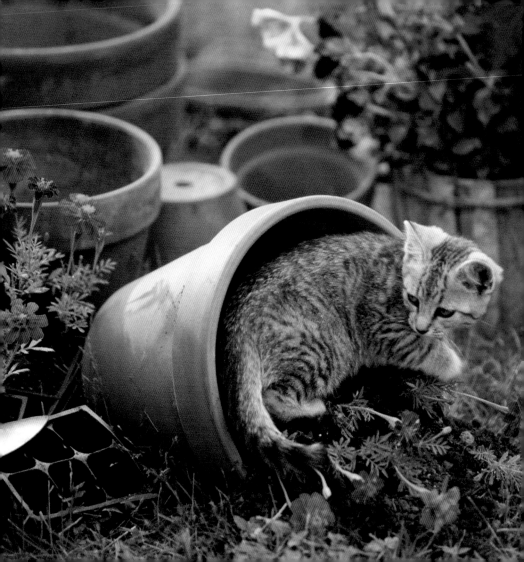

There is no more intrepid explorer than a kitten.

JULES CHAMPFLEURY

Thousands of years ago, cats were worshiped as Gods. Cats have never forgotten this.

ANONYMOUS

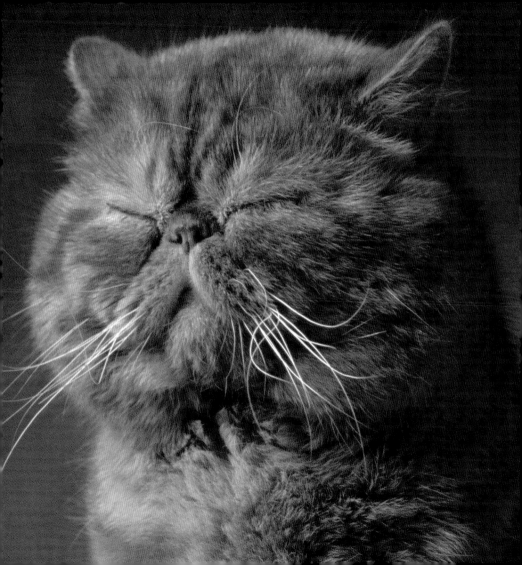

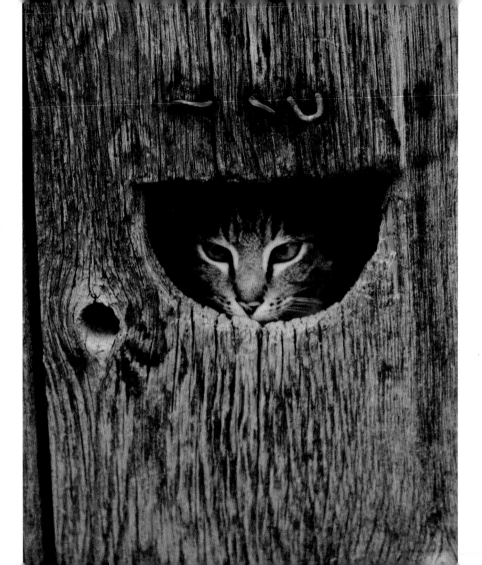

Even a cat is a lion in her own lair.

INDIAN PROVERB

He who flees from trial confesses his guilt.

PUBLILIUS SYRUS

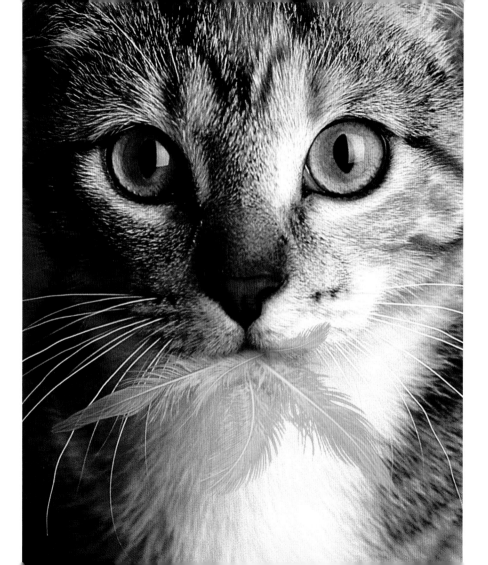

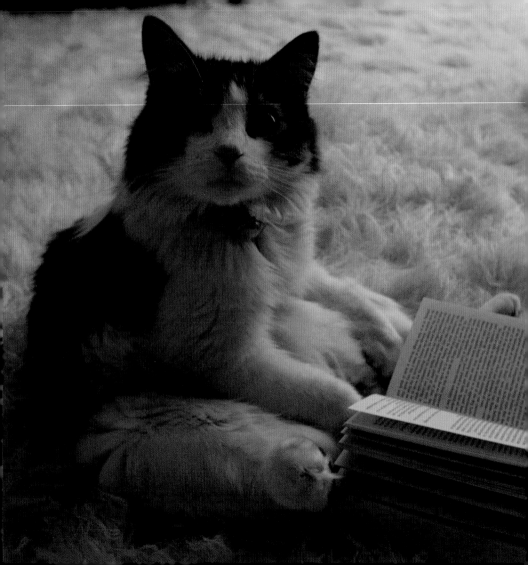

My personal hobbies are reading, mousing, and listening to music.

ANONYMOUS

**If you,
Like me
Were made of fur
And sun warmed you,
Like me
You'd purr.**

KARLA KUSKIN

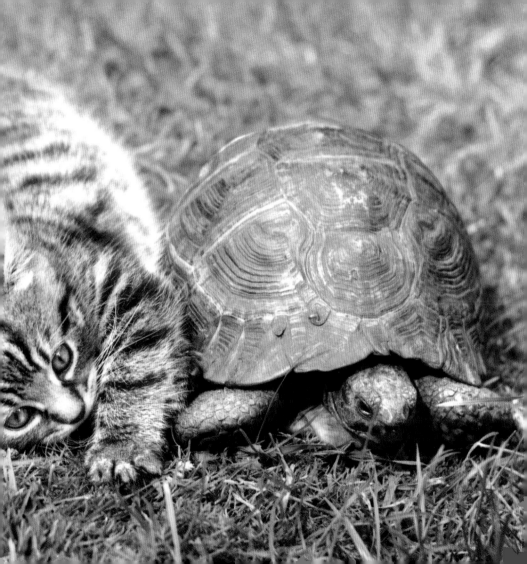

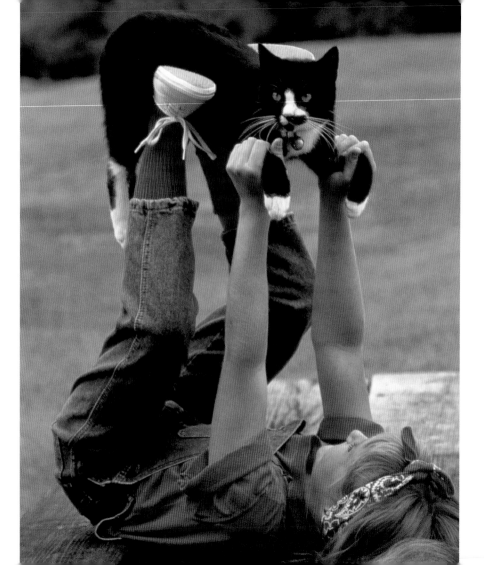

Her function is to sit and be admired.

GEORGINA STRICKLAND GATES

The smallest feline is a masterpiece.

LEONARDO DA VINCI

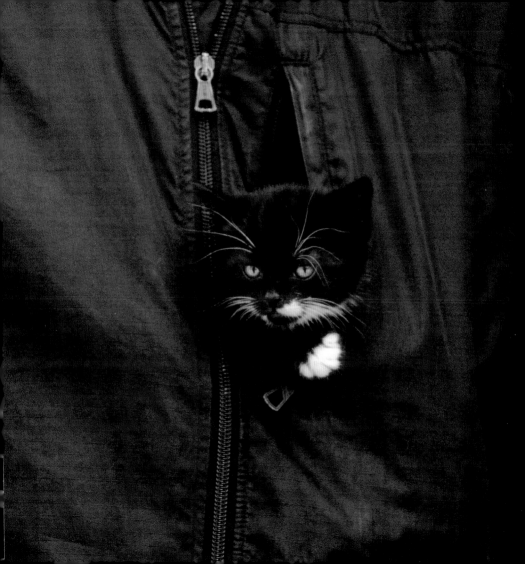

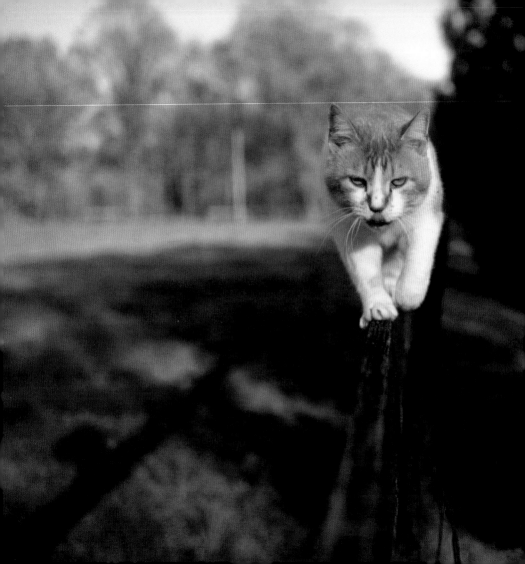

Cats do not go for a walk to get somewhere but to explore.

Sidney Denham

She will attempt nothing that she cannot do well.

K. C. McIntosh

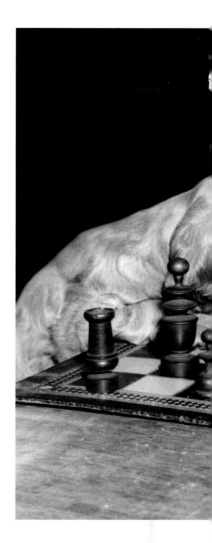

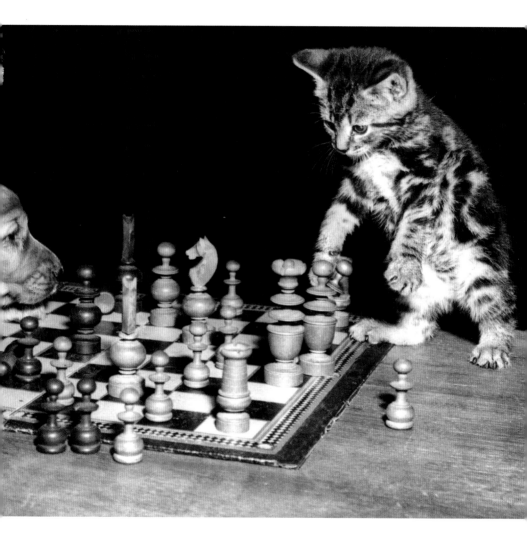

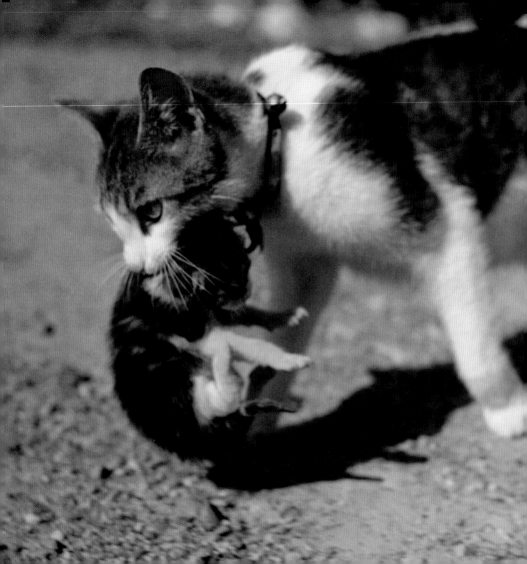

Simplicity is making the journey of this life with just baggage enough.

CHARLES DUDLEY WARNER

Kittens are born with their eyes shut. They open them in about six days, take a look around, then close them again for the better part of their natural lives.

STEPHEN BAKER

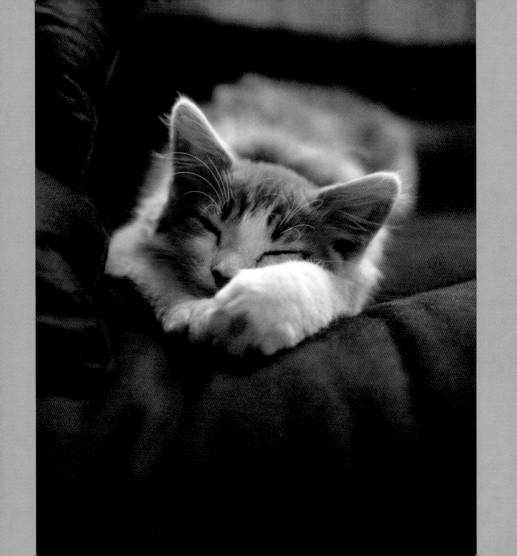

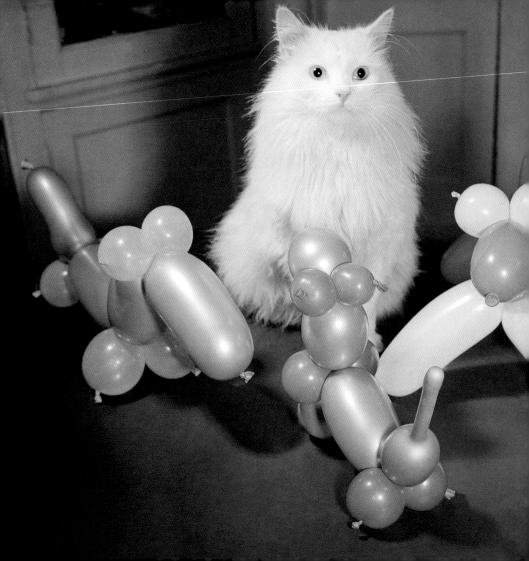

Winny and I lived in a house that ran on static electricity…If you wanted to run the blender, you had to rub balloons on your head. If you wanted to cook, you had to pull off a sweater real quick.

STEVEN WRIGHT

How long can you be cute?

GOLDIE HAWN

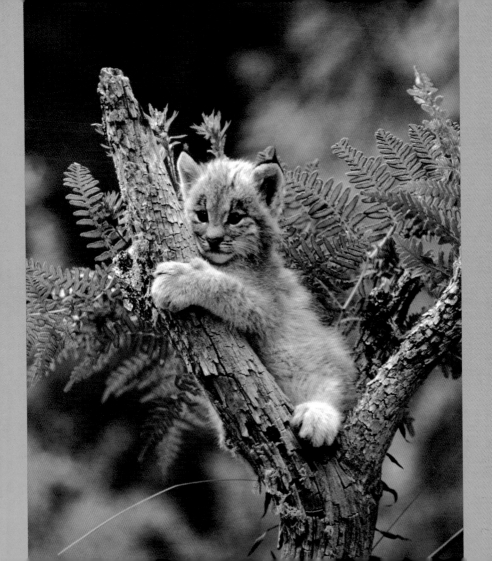

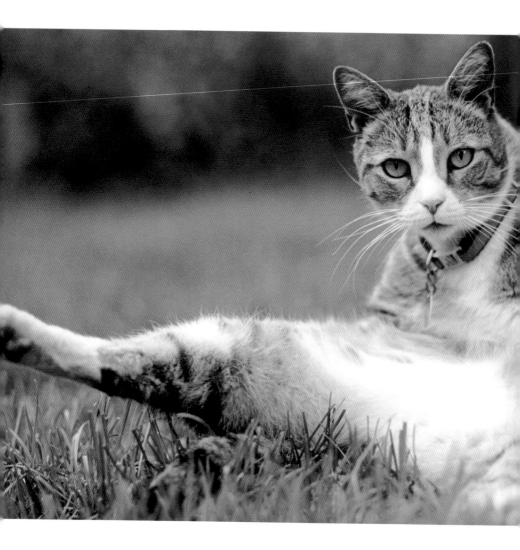

There's no need for a piece of sculpture in a home that has a cat.

WESLEY BATES

When she walked…
she stretched out long and
thin like a little tiger, and held
her head high to look over
the grass as if she were
treading the jungle.

SARAH ORNE JEWETT

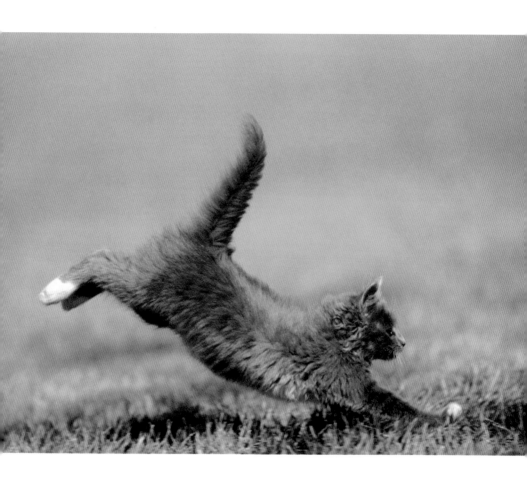

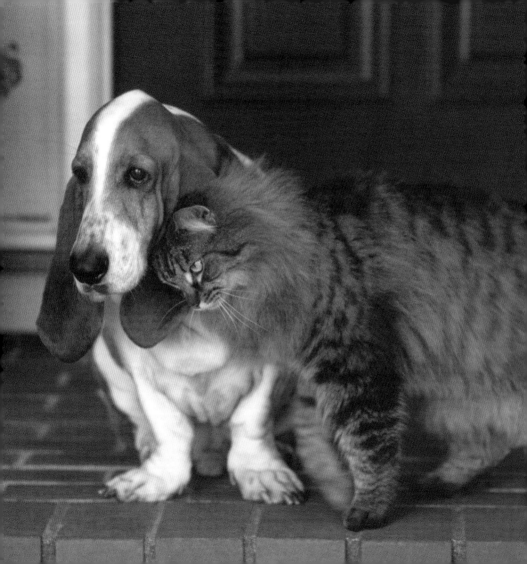